all the words are yours

haiku on love

tyler knott gregson

A Perigee Book

PERIGEE

An imprint of Penguin Random House LLC

375 Hudson Street, New York, New York 10014

ALL THE WORDS ARE YOURS

ISBN: 978-0-399-17600-5

First edition: October 2015

PRINTED IN THE UNITED STATES OF AMERICA

10 9 8 7 6 5 4 3 2 1

sly

Introduction

Sitting on an airplane more than six years ago, I never would have imagined I'd still be doing this, here, today. I never would have imagined that after all this time, all these days, I would still have words left to write. I began the Daily Haiku on Love as a way to dive deeper into the subject of love, to see it in a way I hadn't before. In the introduction to my first book, *Chasers of the Light*, I spoke about trying to find the miracles in the mundane, the epic made simple. In this book, this small collection that represents a greater and still growing whole, I have tried to choose haiku that continue this mission.

Traditionally, haiku are about, or at the very least contain a reference to, the natural world. While some of mine lack a seasonal or natural theme, to me there is no force more natural, or fully unexplored, than love. By challenging myself to notice the smaller, subtler manifestations of the emotion every single day, I hoped to learn more about it, and myself. Six years and more than two thousand haiku later, I realize I have so much more to learn.

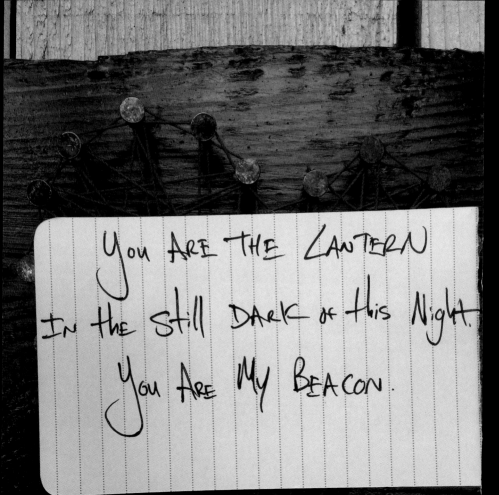

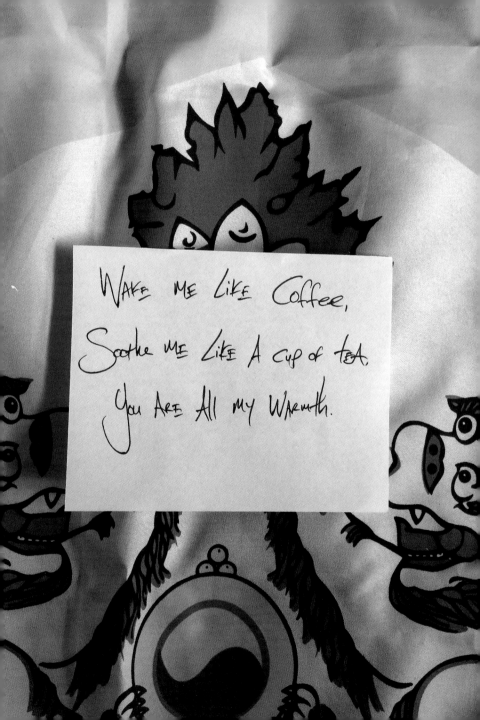

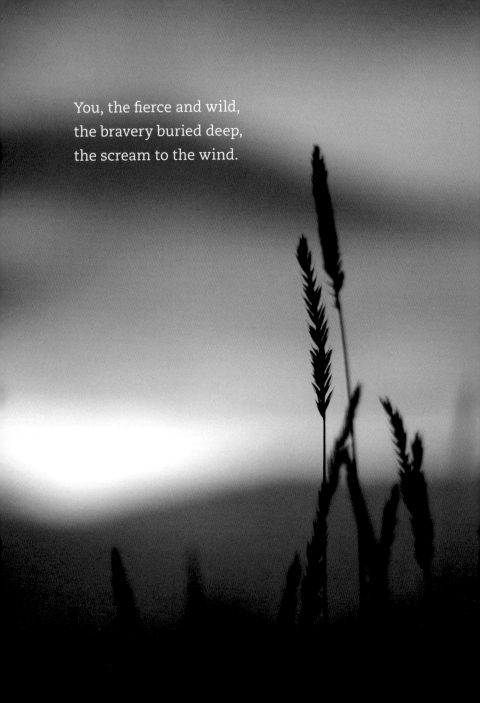

You, the fierce and wild,
the bravery buried deep,
the scream to the wind.

Here, under the stars
and there too, under the clouds,
everywhere with you.

I know not the when
or the why of all of this,
I just know it's you.

In the DARKEST PART,

In the MiDDle of the Night,

I NEED you the Most.

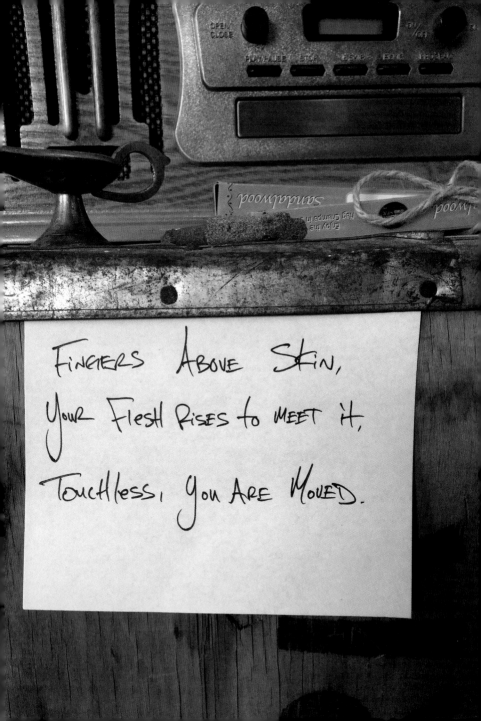

I want my days filled
and my nights saturated
with the sound of you.

"Do you find comfort knowing I belong to you, that I am always yours?

You will NEVER feel,
Not for A single Moment,
that I Don't Love you.

Slow fingers dragged down,
spine like an empty highway
I will wander down.

I split in pieces,
A murmuration of me,
They all flew to you.

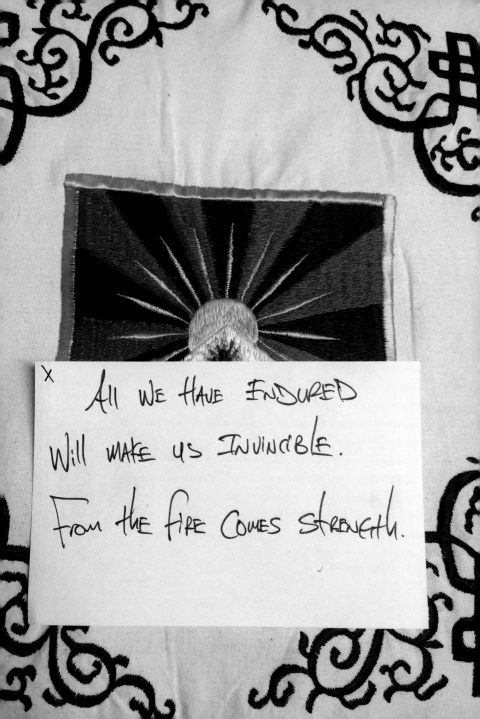

Brighter, now brighter,
pay no mind to those who squint,
burn with all your heat.

It's you before me,
it has always been that way,
it will always be.

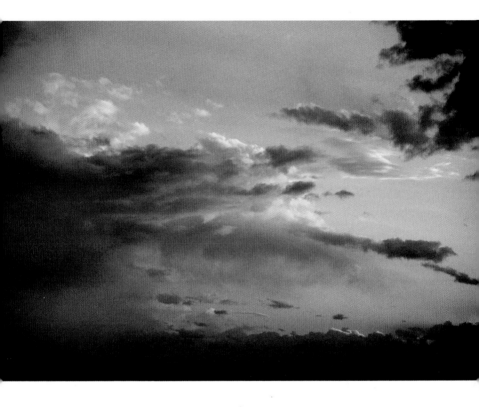

The blur of made love,
the hazy glow of morning,
the sleepy kisses.

Sometimes I want less,
less clothing and less waiting,
less words and less space.

Leaning on Headboards
And Holding you in my Lap,
Tighter We will Hold.

It's what lives inside,
the thoughts and dreams that make you,
that lock me to you.

I think of your Arms

And the soft scent of your Neck.

I think of your Lips.

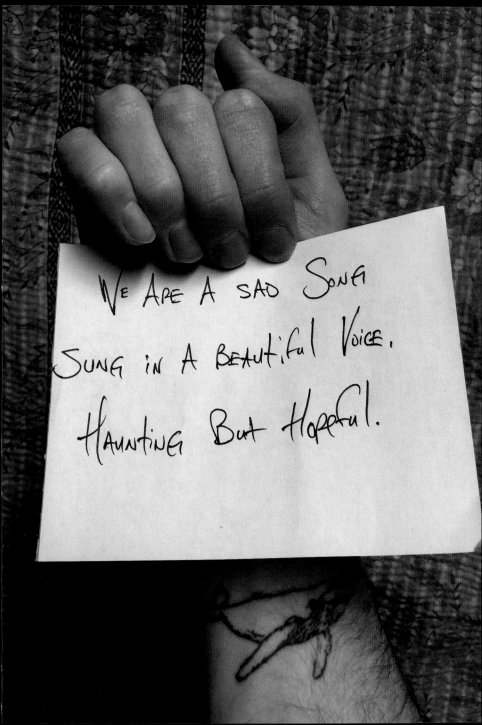

We too can rise up,
we too can float like lanterns
to a better place.

LET'S START WITH TODAY,

WE CAN LET FOREVER COME

AS SLOW AS IT WANTS.

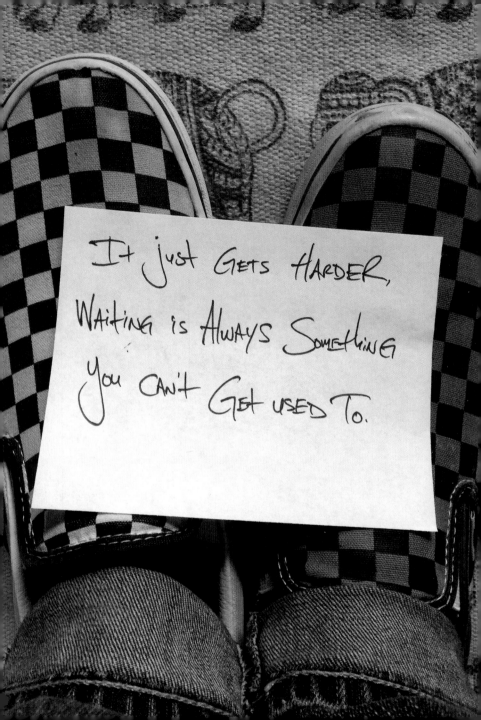

So often I burst,
this heart cannot hold it in,
so often you smile.

x

There's time we can waste

And there's time we must treasure,

Please have both with me.

Lay down your roots now,
let them wrap tight around mine,
sink deep in the soil.

The pieces you lack
are waiting inside me
to find you again.

You are exactly
precisely and perfectly
what I waited for.

You Blossom in Snow.

When All others fear the Cold,

Your Petals Emerge.

Rainfall come to us,
come to wash away this hurt,
come to make us new.

Houses are not homes,
we're not made of bricks and stones.
Home is you and me.

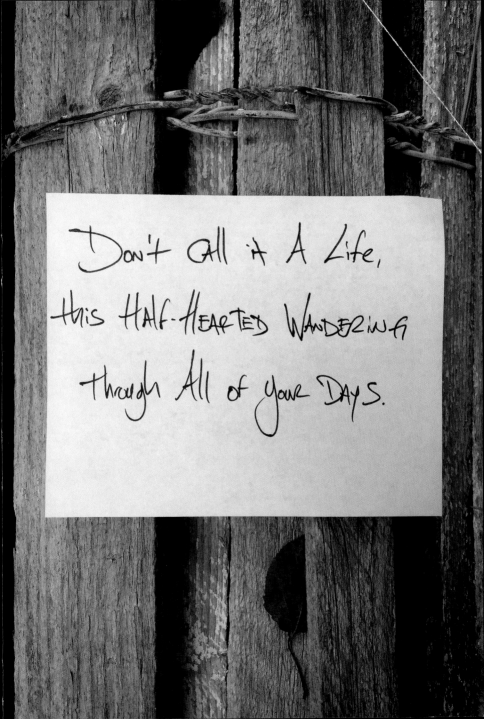

Reach like leaves for you,
you the sunlight that took years
to find your way home.

Your fingers indent,
leaving dimples on my skin
and goosebumps behind.

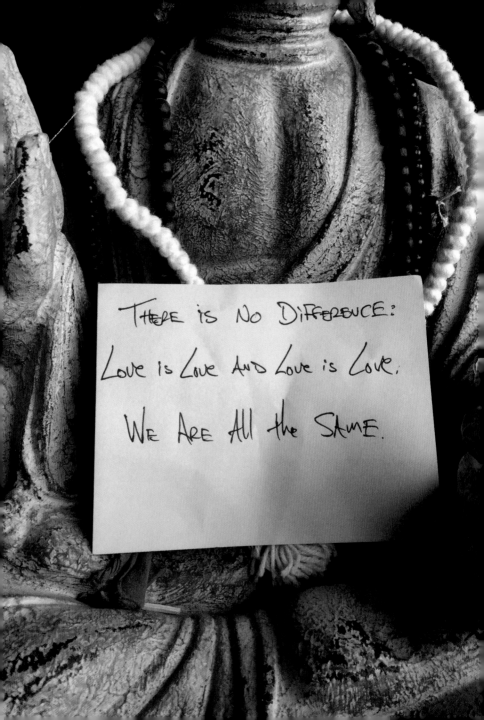

It is unspoken,
all the passion between us.
Will it stay that way?

Stare Before I Leave,

And let the Grin in your Eyes

Linger inside me.

It's ok you know,

To BE CARRIED Now And then,

Strength too NEEDS A REST.

We are what we choose,
the people that we let stay,
the things that we keep.

Your soul knew my soul
long before we needed skin
to spend a life in.

Endure with soft grace,
a strength that needs no shouting
a silent resolve.

I am made of more;
more than tears, more than heartache,
more than all of this.

Gregory Alan Isakov

I SAW NO FIREWORKS
AND HEARD NO CELEBRATION.

I slept without you.

We Must Let it Go

All the Dust Atop our HEARTS,

WE must Blow it FREE.

Back against the wall
and your legs around my waist,
I kiss you again.

Plant you next to me,
Let our roots snake together.

Watch now as we grow.

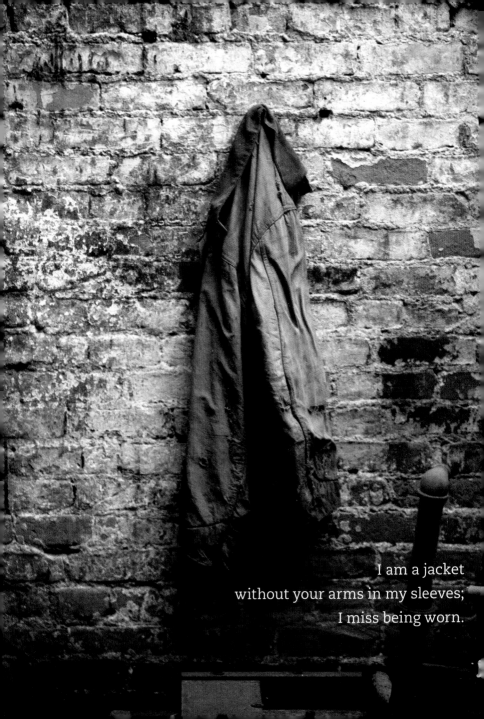

I am a jacket
without your arms in my sleeves;
I miss being worn.

The shadows of us,
the remnants of who we were,
fade now in the light.

I HAVE SIMPLE NEEDS,

JUST YOU AND MY MORNING TEA,

THE MOMENT I RISE.

I AM NOTHING MORE

THAN A million thoughts of you

Swimming inside ME.

LET'S FIND THE PLACES

AND LET'S DO ALL OF THE THINGS

WE'VE WAITED TO DO.

I hope you can see
how very hard I'm trying
to ease this aching.

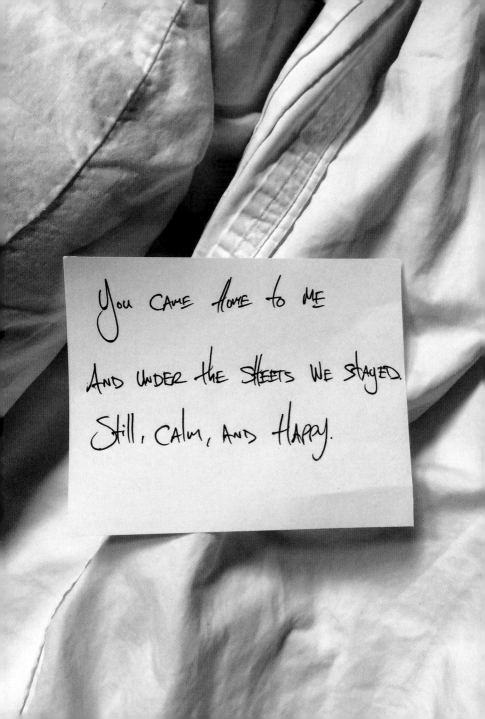

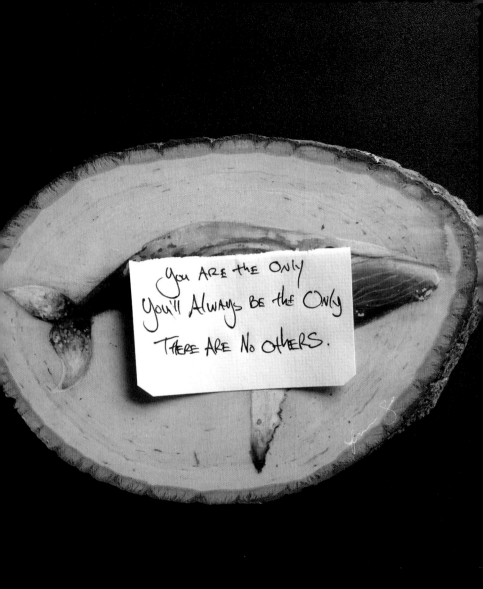

I breathe easier
with the weight of your body
lying on my chest.

Before our skin met
I dreamt of how it would feel
pressed close against mine.

You stared silently
and pressed me against the wall,
kisses before words.

Joy in our Laughter

And Peace in our Arms that Hold.

We Are the Relief.

The lights are waiting
with the music in the streets.
The love is coming.

Roll across the bed
and don't stop until your skin
finds its way to mine.

Pull closed the Zipper
And Grab tight All your Luggage.
The Road is Calling.

More than Anything,
More than Every Single thing,
You Above them All.

Head on quiet lap
with fingers in sleeping hair,
I fell into you.

They're just syllables,
But they carry all the weight

Of the love we make.

You are filled with doubt
of the magic inside you,
but it's all I see.

I will stay Gentle

No matter what I endure,

I am so much more.

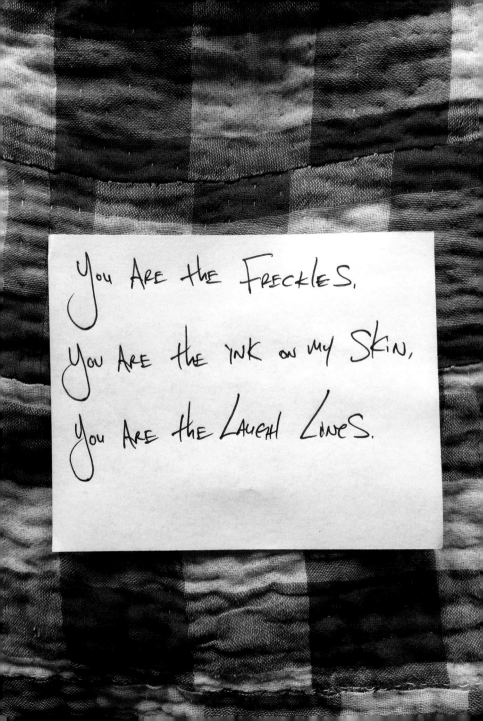

Ocean for a heart
and I will be the lonely ship
to sail upon it.

I think Time Forgot

And Slowed Itself to A Stop

When I found your Eyes.

Be patient and wait,
I'm always in the process
of becoming more.

THE Clouds HAVE PULLED IN

AND All I CAN think to WANT

IS You in this BED.

Will you come see it?
The world that lives beyond this,
the wonder beyond?

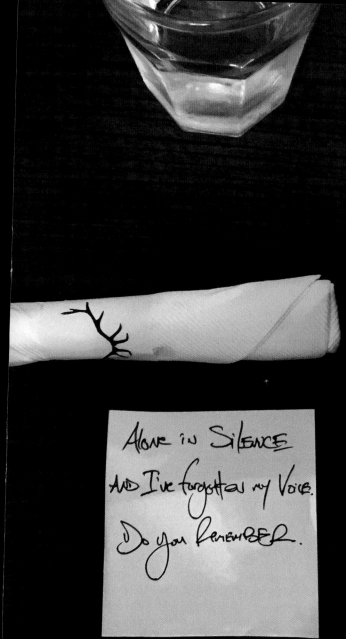

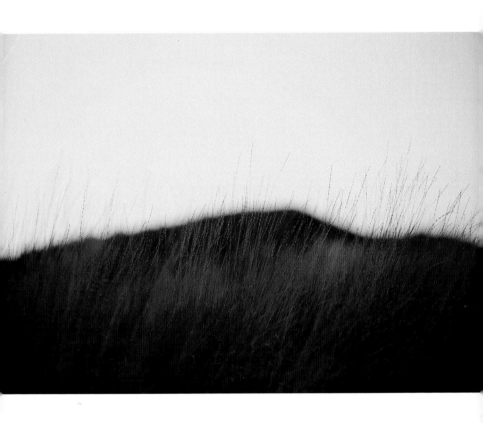

Whisper to me soft,
sing a song of homecoming,
hum me back to you.

I want to feel it,
the breathtaking certainty,
that comes with our love.

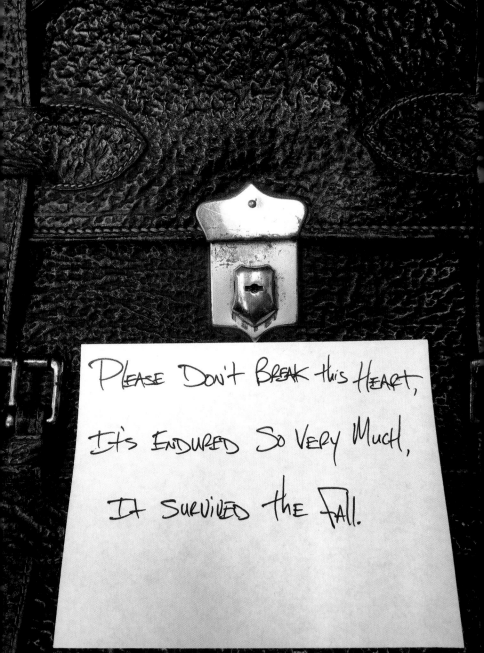

You're the only one
to unbutton and unlock,
to soothe and excite.

There will be words left
but I won't stop saying them,
no time for them all.

I don't want to know
I don't want to imagine
a world without you.

URED PICTURED
OPEDIA ENCYCLOPEDIA

THE
PRACTICAL
GUIDE
TO HEALTH

L. 9 VOL. 8
-ZWI SEA-VIE TO HEALTH

AGES
3-40
TLINE

COMPT
OMPA

I'll Be Waiting Here

Across the Deep Dark Waters

For You to swim Home.

I'm knocking down walls
and climbing over fences.
Your heart will be safe.

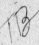

Early morning moans
and your longest stretching groans,
I can't wait to wake.

All of our Minutes
Seem to Last So much Longer,
We make More of Less.

Forgive my fingers
for when they find your body
they will lose themselves.

sly

Let's tangle them up,
twist together All our LimBS,
BraiD ourselves to sleep.

The Gregson Crew

POVERTEES

Thank you for helping fill this bed.

Who else would love me,
All the crazy inside me,
All of this Madness?

There lacks a filter
between my heart and my hands,
I love in touches.

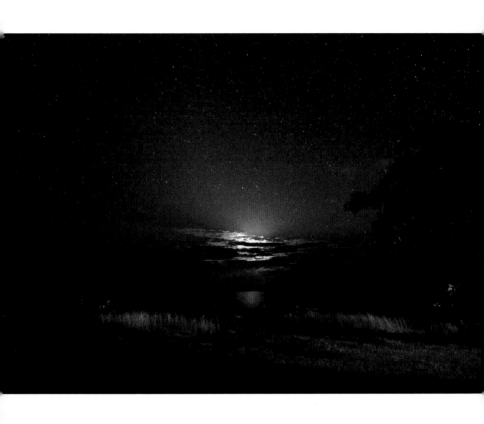

The stars came out to watch,
and the moon peeked out to see,
they watched what we were.

Let it all crumble,
let all you shouldn't carry
burn beneath your feet.

Let's just stay in bed
and we'll let the day dissolve.
Let's stay lost in sheets.

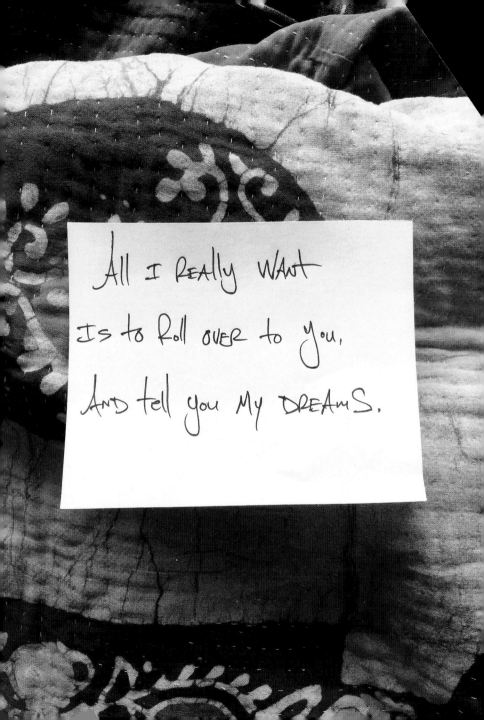

Love me as I am,
see me for who I will be,
forgive who I was.

I will Not Love You
Only in Percentages,
You Get All of me.

The craving for you
never seems to slow itself,
never seems to stop.

I find you in storms,
I feel you in the lightning,
I miss you in rain.

I'll be your deep breath,

I'll be your simple relief,

I'll be home to you.

Invent me a word
that can encompass this ache,
'missing' is too small.

I would RATHER HURT

AND WALK through the flames you LEAVE

THAN NEVER feel you.

chasers
of the
light

You Are the Habit

that I will spend My lifetime

Trying Not to Break.

-Tyler Knott Gregson-

And when you see me,
jump into my waiting arms,
kiss my lonely lips.

WE ARE THE LIVES TOUCHED,

WE ARE THE WORLD WE HAVE CHANGED,

WE ARE MORE THAN HERE.

Just keep waking up,
dragging yourself out of bed.
It will get better.

We Are Unfinished,
We Are the Not yet Begun,
We Are what's Waiting.

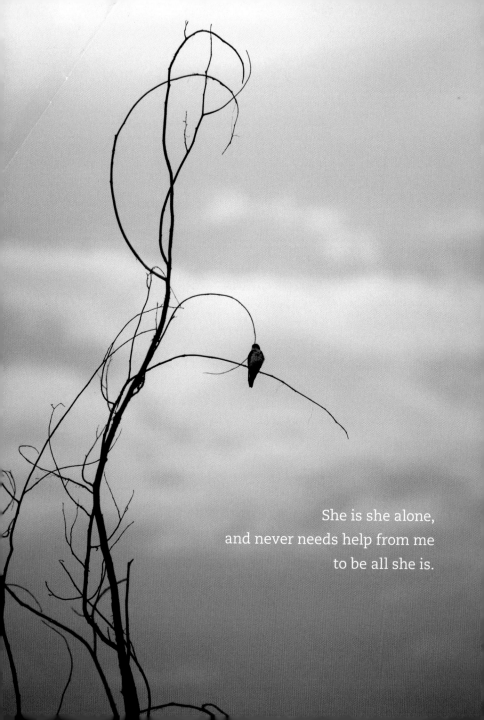

She is she alone,
and never needs help from me
to be all she is.

I'll celebrate you
today and all other days.
I need no excuse.

Mouth made for kissing
and whispering promises
of still more to come.

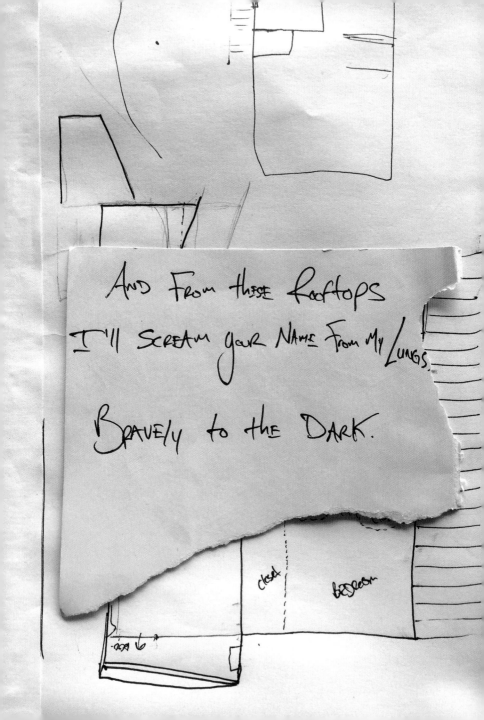

I'll never ask you
to be anything other
than exactly you.

When I roll over
and shake the sleep from my skin,
I want to find you.

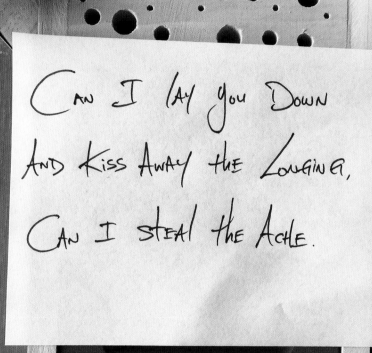

WHATEVER I FIND
I WANT to FIND it with you.

Always AND Only.

You Are More than Words
And the letters that Make them,
You Are Poetry.

I wish I had more,
more letters, more words, more time
to write all you are.

All the words are yours
And they will always be yours.
You live, so they do.

Acknowledgments

I am a man made of many, a combination of those I love and those who love me back. I am composed of all who have helped me, all who encouraged, taught, supported, and believed. "Thank You" feels too small sometimes, and in this case, abundantly so. Nevertheless, I need to say it, I need to try. Thank You to each and every one of you who made this possible, for planting wanderlust in my heart, for tolerating and maybe even loving all of my oddities, for fighting for me, for seeing things in me I never have, and for daring to see the world how I do, if even for a moment. Thank You to all of you, from all of me. Trust when I say all the words are yours.

About the Author

Tyler Knott Gregson is a poet, author, professional photographer, and artist who lives in the mountains of Helena, Montana, along with his two golden retrievers, Calvin and Hobbes.

When he's not writing, he owns and operates his photography company, Treehouse Photography, with his talented partner, Sarah Linden. They photograph weddings all over the world, and just like his poems, their photos attempt to capture the silent moments, the hidden glances . . . big things made small, small things made big.

tylerknott.com

Instagram: @TylerKnott

Twitter: @TylerKnott

Facebook: facebook.com/TylerKnottGregson

Pinterest: pinterest.com/TylerKnott

treehousephotography.org